Pablo Picasso

The Museum of Modern Art, New York

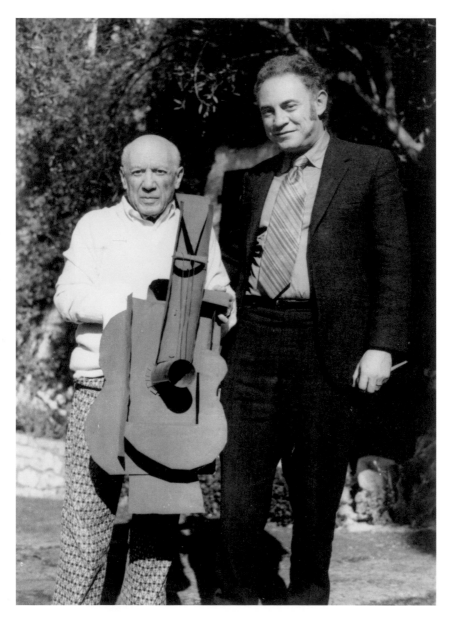

Pablo Picasso and Museum of Modern Art
curator William Rubin with Picasso's *Guitar*
(1914), 1971. Department of Public Information
Records, The Museum of Modern Art
Archives, New York

This book presents thirteen works chosen from the more than 1,200 pieces by Pablo Picasso in the collection of The Museum of Modern Art. The first work by Picasso to enter the Museum's collection was the 1909 drawing *Head of a Woman*, acquired in 1930, when the Museum was one year old. In 1934 MoMA acquired *Green Still Life* of 1914, its first major painting by Picasso, which was followed in 1938 and 1939 by two of his best-known works: *Girl Before a Mirror* (discussed here on page 31) and *Les Demoiselles d'Avignon* (page 10). The Museum held its first Picasso retrospective in 1939, featuring more than 360 works, only thirteen of which were then owned by MoMA; another retrospective followed in 1946. The Museum celebrated Picasso's seventy-fifth birthday, in 1957, with a third retrospective and his eightieth and ninetieth birthdays with exhibitions drawn from MoMA's ever-growing collection of his work. By 1980, seven years after Picasso's death, the Museum owned 1,100 objects by the artist, and in that year and in 1989 and 1996 it mounted major exhibitions of his work. This volume is one in a series featuring artists represented in depth in the Museum's collection.

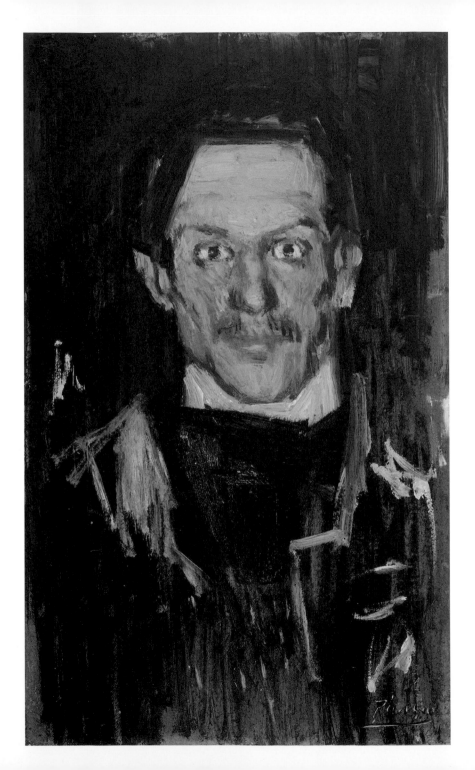

Self Portrait (Yo) (1901)

Pablo Picasso was born in 1881 in Málaga, Spain, and lived in France from 1904 until his death in 1973. During those seven decades he received more attention than any other artist of any period. In early 1901, when he made this image of himself, he was not quite twenty-one, in the middle of his second trip to Paris, impoverished, and virtually unknown. Yet, clearly ready to take on the future, he presents himself with stark, head-on immediacy. His pose resolutely frontal, he fixes the viewer with the penetrating gaze that would unsettle recipients throughout his life. Fernande Olivier, his companion from 1904 until 1912, described his eyes as "dark, deep, piercing, strange, and almost staring."

The picture's stunning effect of unmediated physical presence is crucially dependent on the vigor and assurance of Picasso's brushwork. The face, modeled in short, swift jabs of warm color, is set against a dark, largely indeterminate ground of slashing, rectilinear strokes that do not model form but are laid flat on the plane of the support. Particularly dramatic are the angular swipes of blue forcefully describing the hairline and extending beyond it. It may be that these sticklike marks owe

Self-Portrait (Yo) 1901
Oil on cardboard mounted on wood,
20 ¹/₄ x 12 ¹/₂" (51.4 x 31.8 cm)
The Museum of Modern Art, New York
Mrs. John Hay Whitney Bequest, 1998

something to Vincent van Gogh, whose influence was important to Picasso in 1901. In retrospect they might be seen as premonitory of certain kinds of gestural expressionism. Picasso's later view of this youthful image of himself was articulated in a comment he wrote on a photograph showing it: "This photograph might be titled: The strongest walls open on my passage. Look!" At the time, his directive was more briefly contained in the Spanish one-word declaration "*Yo*" (myself) inscribed in the picture's upper-left corner.

Boy Leading a Horse

(1905–06) Picasso made this grand painting during a period when his interest in ancient sculpture was so intense that a friend described him as "pacing around and around like a hound in search of game" in the Louvre's antiquity galleries. The corridors of that great museum were not, however, his sole stalking grounds. Among others, the 1905 Salon d'Automne, with its display of paintings by Paul Cézanne, was prey to his hunting instincts. The ideas he brought back from such expeditions were critical to his efforts to excise the charm and Symbolist sentimentality that had pervaded his pictures of melancholy circus performers during most of 1905.

At year's end and into 1906, sketches Picasso was making for an ambitious *saltimbanque* scene gradually became more and more simplified, and the circus motif eventually gave way to a vaguely narrative friezelike composition of naked youths and

Boy Leading a Horse 1905–06
Oil on canvas, 7' 2 7/8" x 51 5/8"
(220.6 x 131.2 cm)
The Museum of Modern Art, New York
The William S. Paley Collection, 1964

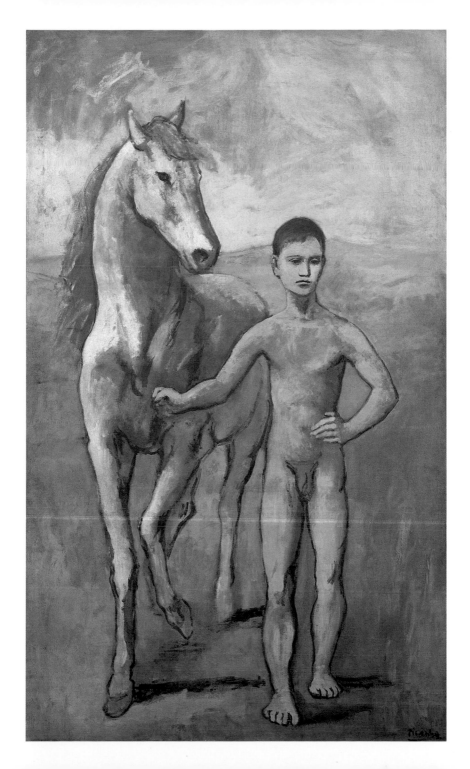

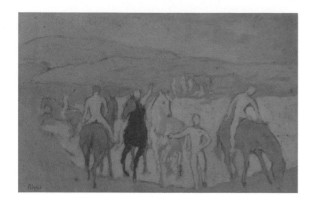

horses, realized in a small gouache titled *The Watering Place* [fig. 1]. Picasso did not take the project further. Instead of converting the multifigured gouache to oil on a mural-size canvas, he used only its two central figures, a dismounted boy and his horse, as the subject of a monumental vertical composition. (It has been suggested that with the change of subject he simply rotated the horizontal canvas he had prepared for a larger version of *The Watering Place*.) The solitary pair moves through a barren landscape devoid of locational cues—an unnameable, timeless region. In this mythic world, magic rules. Without reins the boy leads the horse by the sole authority of his gesture—a parallel, surely, with the power of the artist's hand. Ten years earlier the fourteen-year-old Picasso had made drawings from a plaster reproduction of the Parthenon's frieze of riders and horses, which may also have had a part in the formation of his concept. But the painting's most direct tie to the antique is the configuration of the boy's body. Greek *kouroi*, sculptures of nude young men from the fifth and sixth centuries BCE [fig. 2] designed to celebrate the male anatomy at the moment of its first maturity, are unequivocally genetic relatives of Picasso's striding youth.

8

1 *The Watering Place* 1906
Gouache on pulp board, 15 x 22 ³/₄"
(38.1 x 57.8 cm)
The Metropolitan Museum of Art, New York
Bequest of Scofield Thayer, 1982

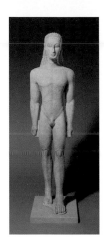
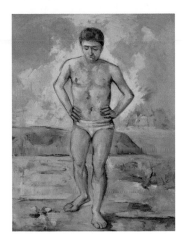

Heritage is usually mixed, and that of this horse-taming young magician is no exception. Picasso had discovered in Paul Cézanne—the "*primitif classique*" of modern painting—a source to complement the antique. While similarities exist between *Boy Leading a Horse* and several of Cézanne's male nudes, its direct model would seem to be his painting *The Bather* of around 1885 [fig. 3]. Affinities between the two paintings are striking. Like Picasso's boy, Cézanne's bather is absolutely frontal, his body sculpturally, if sketchily, modeled and contained within a dark contour line. Alone in an imprecise, enveloping void, each figure advances, eyes averted, toward the spectator. Where Picasso's idealized youth exists in an environment of gray and pinkish-brown, suggesting the weathered surfaces of an archaic world, Cézanne's awkward older man is surrounded by variations of blue, green, violet, and rose, evoking the atmosphere of a summer day. However sited, both figures seem to possess the earth they walk on and are modeled with the same multiaccented, overlapping brushwork as the landscapes surrounding them. The merging of Greek sculpture and the art of Cézanne so

9

masterfully accomplished in *Boy Leading a Horse* shows Picasso sharing the older artist's will to make an art that would be "solid and durable like the art of the museums."

Les Demoiselles d'Avignon

(1907) Announcing The Museum of Modern Art's purchase of *Les Demoiselles d'Avignon* in 1939, Alfred H. Barr, Jr., the Museum's director, described it as "one of the very few paintings in the history of modern art which can justly be called 'epoch-making.'" Now, more than a century after it was painted, the picture's extraordinary importance to the evolution of the art of its time and beyond has only been further confirmed. Nor has the painting lost its power to shock. On first encounter a spectator can be as discomfited as were its first viewers. One among them, the painter Georges Braque, felt endangered, "as if someone were drinking gasoline and spitting fire."

In its raw energy *Les Demoiselles d'Avignon* looks like it was painted in one burst of creative fury. It is, however, the result of months of concentrated, wide-ranging experimentation. The hundreds of studies preceding it show the influence of Western art, ancient sculptures of the Iberian Peninsula, and anonymous artifacts of Africa [figs. 4–6], all varyingly apparent in its final form. The fame of the painting is now such that even viewers with little knowledge of modern art are likely aware that its five naked *demoiselles* represent prostitutes (its title, not conferred

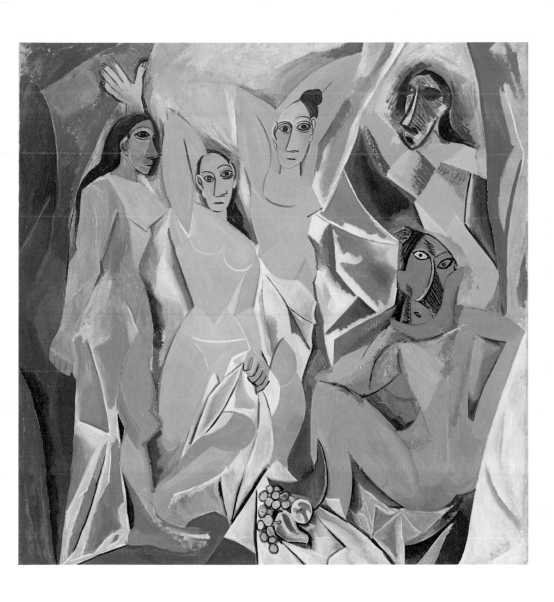

Les Demoiselles d'Avignon 1907
Oil on canvas, 8' x 7' 8" (243.9 x 233.7 cm)
The Museum of Modern Art, New York. Acquired
through the Lillie P. Bliss Bequest, 1939

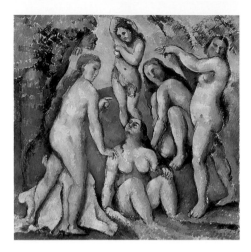

by Picasso, reputedly refers to a notorious house on the Carrer d'Avinyó, a street in Barcelona). Visually, however, their employment is only disclosed in Picasso's preparatory sketches, which evolved from anecdotal brothel scenes to culminate in the enigmatic drama of the final composition.

In fact, nothing very dramatic is going on. Action is confined to the drawing back of a curtain by the woman on the left and the entry of another woman at right. The horrified reaction of the painting's first viewers and the impact it still delivers arise from what the art historian Leo Steinberg called the "explosive debut" of Picasso's "discontinuity principle," whose operations he tallies in his book *The Philosophical Brothel* (1974): "The picture crowds five disconnected figures—not as one group, nor in one ambience, but each singly encapsulated: the lone curtain raiser at left, separated even from her own lifted hand by an unmediated space jump; the second figure stretched forth in reclining position seen from on top—she arrives on the picture plane like a Murphy bed hitting the wall; the straight middle figure adjacent, but with no spatial ties to her sister, seen from

12

4 Paul Cézanne (French, 1839–1906)
Five Bathers 1885–87
Oil on canvas, 25 ³/₄ x 25 ³/₄" (65.5 x 65.5 cm)
Kunstmuseum Basel, Switzerland

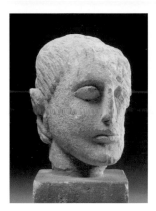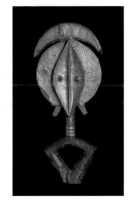

below again. Then those curtain folds like packed ice to quarantine the intruding savage at upper right—treated in a menacing 'African' mode; and lastly—'crouched for employment'—an exotic jade realized like no other, dorsal and frontal at once."

 Steinberg's inspired description catches the urgency of Picasso's bid to sabotage Western art's conventional traditions. His congested composition set in an unnameable environment defies all notions of continuity between form and field. As for perspective, if, following Renaissance dictums, the picture constitutes itself as a window, the view beyond is odd. The blue curtains seem deflected in their forward momentum by the barrier of the picture plane, and all five figures are pressed flat against it. A will to recession seems to belong exclusively to the melon in the animate still life at center, but its scythelike thrust is thwarted by the Cézanneian slant of the table it rests on.

 Of the picture's many ruptures of stylistic unity, the most glaring is the contrast between the faces of the three *demoiselles* on the left and those of the two on the right. The first three, influenced variously by ancient art, are impassive and schemati-

13

5 Iberian head (Cerro de los Santos)
Fifth to third century BCE
Limestone, 18 ¹/₈ x 10 ⁵/₈ x 6 ³/₄"
(46 x 27 x 17 cm)
Musée des Antiquités Nationales,
Saint-Germain-en-Laye

6 Reliquary figure (Kota; Gabon or People's
Republic of Congo) Nineteenth century
Wood, copper, and brass, 15 ³/₄" (40 cm) high
Musée du Quai Branly, Paris

cally modeled; the second two are ominously contorted and described by violent hatching—their origins in African art are apparent. Picasso believed that the African masks that inspired them were "intercessors," capable of warding off dangerous spirits. Later, with this shamanistic duo in mind, he spoke of *Les Demoiselles d'Avignon* as his "first exorcism painting." More intensely expressionist than anything in Fauvism, these two figures embody Picasso's conflicted attitudes toward women and may well, as William Rubin argued, express their creator's immediate fears of contracting a sexually transmitted disease. However interpreted, the painting's brutal demolitions of stylistic and spatial coherence are shortcuts to a merging of rendering and experiencing, to an outcome in which "explosive and erotic content" meld.

Intensifying the picture's symbolic charge is a rare element of unity—its unsettling gaze. Each *demoiselle* peers relentlessly at the beholder. The dark eye of the profiled, curtain-lifting figure at left is implacably frontal; noses splayed, the two with upraised arms stare in lopsided concentration; the squatter glares, hostile and furious; above, her sister squints across the scene with her tiny right eye while the large oval of her left—black and sinister—fixes on her audience. *Les Demoiselles d'Avignon* does not yield easily to visual possession—in Steinberg's memorable words, it fights back "in the startled consciousness of a viewer who sees himself seen."

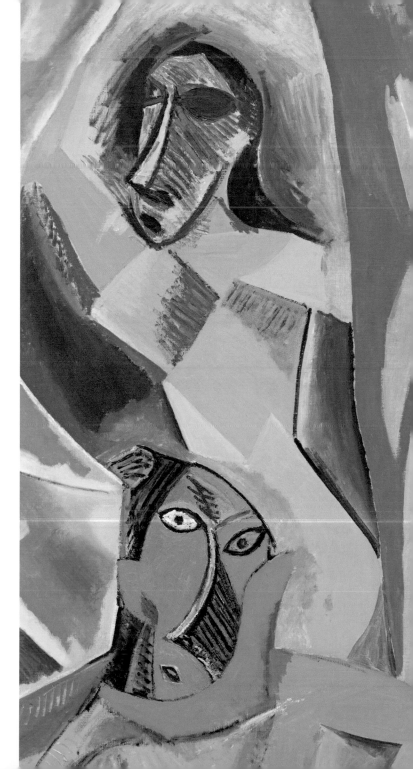

Les Demoiselles d'Avignon (detail)

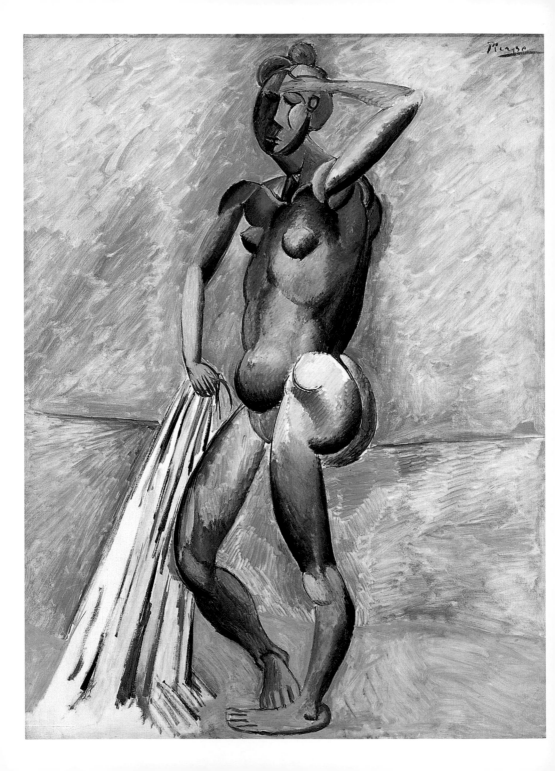

Bather (1908–09)

During the eighteen months or so separating *Bather* from *Les Demoiselles d'Avignon*, Picasso engaged in a more and more curious reengineering of the female form. For sheer unleashed ingenuity, however, this bather has no prior competition. Her extraordinary deformations largely result from Picasso's evolving progress toward the full development of what we now know as Analytic Cubism, abetted by his abiding interest in sculptural forms. Given the artist's delight in caricature, it may reasonably be conjectured that some spirit of the comic also played a role in the fashioning of this bather's unusual anatomy. Her demeanor and parts inspired the following description by Kirk Varnedoe: "This improbably preening creature, with her pile-driver haunch, bowling-ball belly, tiny breasts, and segmented little anthropod arms, has a comically smug, closed-eyes equipoise and is rendered with a fine-brushed, mincing precision that seems at odds with the radical reformations of her anatomy."

Picasso's tendency toward the sculptural is evident here in the way that profile, three-quarter front, and three-quarter back views are simultaneously delivered. This division of structure anticipates the more refined faceting of Analytic Cubism that was shortly to come, and is an early demonstration of Picasso's lifelong obsession with eliminating the boundaries of perception through images that show the invisible and visible sides of a body at once. The bather's incongruously alluring pose shows her left leg in full profile while the right swivels frontally; above, the middle of the abdomen and right breast are pro-

Bather 1908–09
Oil on canvas, 51 $^1/_8$ x 38 $^1/_8$"
(129.8 x 96.8 cm)
The Museum of Modern Art, New York
Louise Reinhardt Smith Bequest, 1995

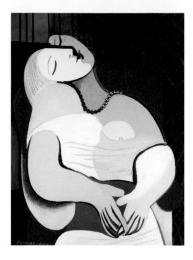

filed. Descending from the left shoulder is a dark line that could describe a silhouette consistent with the left leg and buttock; however, it equally serves as the middle line of a three-quarter rear view in which the far buttock is parallel to and larger than the near one. The right shoulder has been rotated into full frontality; the back of the frontal left arm rises disconcertingly from a socketlike joint. Ascending from the shoulders is a profiled neck surmounted by a nearly frontal head, but a sharp separation of light from shadow divides the full face to display a profile within. Art historian Robert Rosenblum pointed out that this is Picasso's first combination of frontal and profile views—an expressive device that served him again and again throughout his career, for example in *The Dream* of 1932 [fig. 7].

If *Bather's* radical opening up of solid volume was useful to Picasso in the elaboration of Cubism, its composition, unequivocally separating figure from ground, was irrelevant to that movement of exquisite pictorial nuance. Indeed, much of the canvas's extraordinary impact comes from the isolation of the

18

7 *The Dream* 1932
Oil on canvas, 51 ¹/₄ x 38 ¹/₈" (130 x 96.8 cm)
The Wynn Collection, Las Vegas

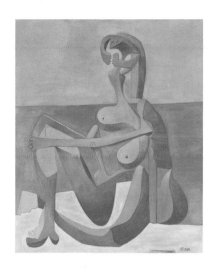

cleanly delineated edges and robustly shaded volumes of the bather against a schematic, thinly brushed vista of beach, sea, and sky. Although bypassed by Cubism, *Bather*'s compositional format returned in the artist's sometimes misogynist "bone" figures of the late 1920s and early 1930s, such as *Seated Bather* [fig. 8], set in monumental silhouette against sunny seascapes.

"Ma Jolie" (1911–12) An example of
Analytic Cubism's highest, most abstract moment, *"Ma Jolie"* has a solidly traditional theme: a young woman holding a musical instrument. In this case she is Picasso's companion, Eva Gouel, whom he calls *"ma jolie"* (my pretty one) after a line in a popular song. Her presence is, however, evanescent—permeating the picture and permeated by it. At the upper center are traces of her head and perhaps a fugitive smile. A triangular form in the

19

8 *Seated Bather* 1930
Oil on canvas, 64 ¹/₄ x 51" (163.2 x 129.5 cm)
The Museum of Modern Art, New York
Mrs. Simon Guggenheim Fund, 1950

lower center displays the strings of a zither or guitar; below are four fingers with an angular elbow to the right. At the very bottom a treble clef, a stave, and, to the left, a wine glass hint at a pleasant interlude in the studio.

Figure and objects, absorbed within a shallow allover field of planes, shading, lines, and schematic spatial clues are but traces of themselves. Lines reading as the edges of semi-transparent planes diagrammatically cue the eye to locate parts of the body and objects not as they might be seen at once, but in a combination of different views and moments. This expansion of visual grasp, initiated three years earlier in *Bather*, has evolved here to a radical format of virtually abstract illusionism. Description is preempted in favor of an overall pictorial concept, and color is restricted to a Rembrandtesque palette of browns, tans, and grays. The sculptural handling so apparent in *Bather* has been replaced by a painterly treatment of lively, almost Neo-Impressionist brushstrokes.

The reordering of perceived reality in "*Ma Jolie*," together with its emphasis on surface and touch, puts us on notice that we are dealing with an image that is both visual and conceptual. Years later, musing on Analytic Cubist pictures such as this, Picasso said, "All its forms can't be rationalized. At the time, everyone talked about how much reality there was in Cubism. But they didn't really understand. It's not a reality you can take in your hand. It's more like a perfume—in front of you, behind you, to the sides. The scent is everywhere, but you don't quite know where it comes from."

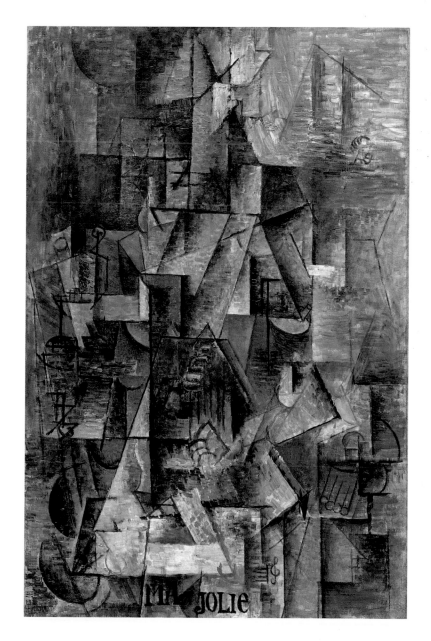

"Ma Jolie" 1911–12
Oil on canvas, 39 3/8 x 25 3/4" (100 x 64.5 cm)
The Museum of Modern Art, New York
Acquired through the Lillie P. Bliss Bequest, 1945

Guitar (1914) From antiquity to the early twenti-
eth century, sculpture was an art of carving and modeling solids.
Its principal mediums—stone, wood, and cast bronze—more
often than not described the human form. In assembling his
unassuming *Guitar*, Picasso quietly broke with age-old traditions
to initiate a sculptural revolution whose consequences have
enabled the work of artists from Vladimir Tatlin through Julio
González, David Smith, and Richard Serra, to name only a few.

 Made from everyday materials—sheet metal, string, and
wire—and replicating a common object particularly favored
by Cubism, *Guitar* was cobbled together like a three-dimen-
sional collage. Pictorial in address, it is without mass—a shallow
arrangement of planes to be viewed frontally. While retaining the
size and shape of his subject, Picasso shattered its form. Where
the front panel of an ordinary guitar encloses its volume, in the
sculpture that panel has been cut away, opening the interior as
an empty box. Where the sound hole is normally a void, Picasso

9 Grebo mask (Ivory Coast or Liberia)
Wood, paint, and vegetable fibers,
25 ¹/₈" (64 cm) high
Musée Picasso, Paris

Guitar 1914
Sheet metal and wire, 30 ¹/₂ x 13 ³/₄ x 7 ⁵/₈"
(77.5 x 35 x 19.3 cm)
The Museum of Modern Art, New York
Gift of the artist, 1971

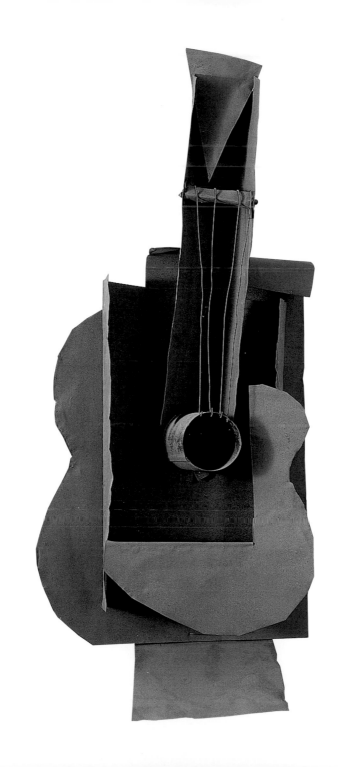

turned it into a projecting cylinder—an idea the artist said was inspired by the tubular eyes in an African Grebo mask [fig. 9]. Opening the core of the sculpture, the cylinder allows us to see into and through it.

The ideas embodied in *Guitar*—that sculpture can be fabricated, its parts disparate, its materials unorthodox, and its subjects unrestricted—are now so accepted that their radicality in the early twentieth century is almost unimaginable. With *Guitar* in mind, the sculptor William Tucker remarked, "It is a strange paradox that the most radical of works should be so modest, drab, even furtive in presence; in contrast, for example, to the enormous attack, vigor, and freshness that the *Demoiselles d'Avignon* have even today." The past and present impact of that 1907 breakthrough painting notwithstanding, the long-term influences of *Guitar* are, along with Cubism, Picasso's richest legacy.

Glass of Absinthe (1914)

This work is the only sculpture in the round Picasso made between 1910 and 1926. One of an edition of six bronzes cast from a wax model, the traditionalism of its technique is undermined by the cutaway form of the glass, the collaged addition of a real absinthe spoon, and the fact that each example is painted differently. If *Glass of Absinthe*'s solid form barred Picasso from achieving the actual transparency of *Guitar*, he could nonethe-

Glass of Absinthe 1914
Painted bronze with absinthe spoon,
8 $^1/_2$ x 6 $^1/_2$ x 3 $^3/_8$" (21.6 x 16.4 x 8.5 cm),
diameter at base 2 $^1/_2$" (6.4 cm)
The Museum of Modern Art, New York
Gift of Louise Reinhardt Smith, 1956

less simulate see-through effects; integrally showing the stem and bottom of the glass, he fractured its real-life conical form. The resulting shapes may have been intended to suggest varying levels of absinthe or planes of light passing through the goblet. Additionally offsetting an appearance of solidity is the pointillist stippling applied here and there in strategic dosages. Picasso's appropriation of Neo-Impressionist brushwork to his own purposes is paralleled in such contemporaneous examples of his Rococo Cubism as *Green Still Life* [fig. 10]. Typically, Picasso's painting and sculpture are in intimate interplay—here, the same decorative device that emphasizes surface on the canvas acts to dissolve it in the sculpture.

However traditional *Glass of Absinthe*'s fundamental methodology may be, it—along with *Guitar* and other objects Picasso made between 1912 and 1915—established the still life as a legitimate subject for sculpture. The artist's attachment of the silver-plated, perforated absinthe spoon to a simulated, bronze sugar cube was the first of many instances in which he incorporated a complete found object into a sculpture. He later reported, "I was interested in the relationship of the real spoon to the modeled glass—in their mutual impact."

26

10 *Green Still Life* 1914
Oil on canvas, 23 ¹/₂ x 31 ¹/₄" (59.7 x 79.4 cm)
The Museum of Modern Art, New York
Lillie P. Bliss Collection, 1934

Three Musicians (1921)
Three Women at the Spring (1921)

In the garage of the villa he rented in Fontainbleau, France, during the summer of 1921, Picasso painted several large canvases, including this version of *Three Musicians* and *Three Women at the Spring*. The former is the culmination of Picasso's Synthetic or Decorative Cubism and the latter is a premier example of his Neoclassicism. Both are monumental in size, share a tripartite simplicity of presentation, and evoke a mysterious sense of gravitas. Otherwise, they are startlingly different.

The musicians, set in a bare, boxlike space, wear carnivalesque costumes evoking stock characters from the *commedia dell'arte*, a frequent theme in Picasso's work. A masked Pierrot plays the clarinet; a singing monk holds sheet music; in the center, strumming a guitar, is Harlequin, a figure Picasso often identified with. The somewhat whimsical aspect of these figures is emphasized by the near-invisible dog splayed out beneath the table, its jaunty tail rising between Pierrot's legs. Overall, however, the masked figures hieratically ordered against a vast expanse of monochromatic browns are a somber, even magisterial trio.

The other trio, the three women arranged in high sculptural relief around a barely indicated spring, is also given majestic presence—but by very different means. The flat, jigsaw-puzzle style of Synthetic Cubism governing the structure of *Three*

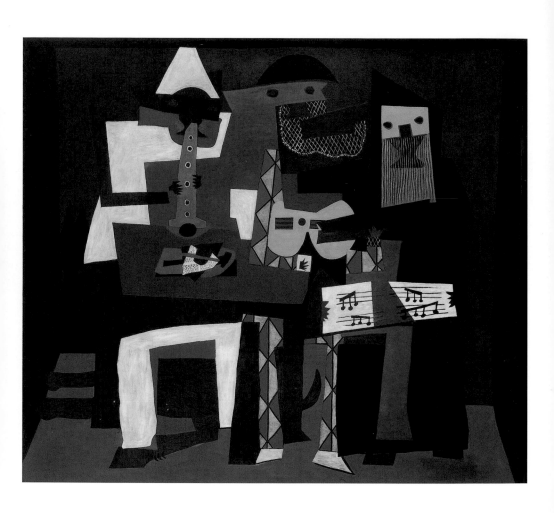

Three Musicians 1921
Oil on canvas, 6' 7" x 7' 3 ³/₄" (200.7 x 222.9 cm)
The Museum of Modern Art, New York
Mrs. Simon Guggenheim Fund, 1949

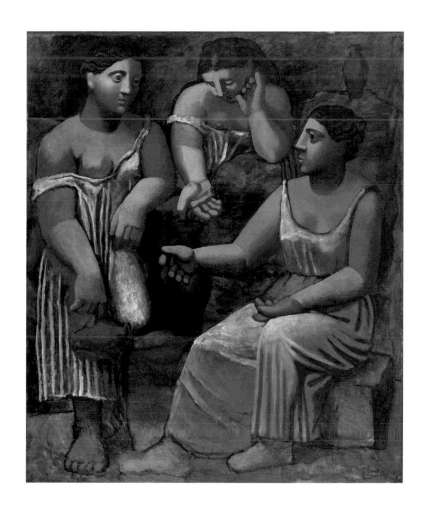

Three Women at the Spring 1921
Oil on canvas, 6' 8 1/4" x 68 1/2" (203.9 x 174 cm)
The Museum of Modern Art, New York
Gift of Mr. and Mrs. Allan D. Emil, 1952

Musicians has no echo in the sculpturally modeled volumes of *Three Women at the Spring*. And where the light hues of the musicians' costumes are a bright center in a surrounding aura of darkness, the women's terra cotta limbs and the marblelike drapery of their garments form a radiant circle around darker, reddish-brown rocks. But the play of light is less operative than gesture in establishing mood in *Three Women at the Spring*. The graceful, ordered choreography of the women's hands suggests the mysteries of some ancient ritual.

Picasso was and still is famous, even notorious, for his artistic zigzagging. These two very different pictures, painted at virtually the same moment, are one example, among many, of the artist's virtuoso command of his means.

Painter and Model (1928)

This is one of the most important of a series of artist-and-model paintings Picasso began in the spring of 1926. He had made studio pictures previously, but it was not until the mid-1920s that the process of painting asserted itself as a subject. The canvases he then produced are, like this one, pictorial meditations on the relation of the artist to the work he creates.

In this classic confrontation of painter and subject, the dramatis personae readily reveal themselves. At the right the artist sits on a yellow-patterned chair whose back rises like a prehensile tail. His head and tripod figure closely resemble a painted metal

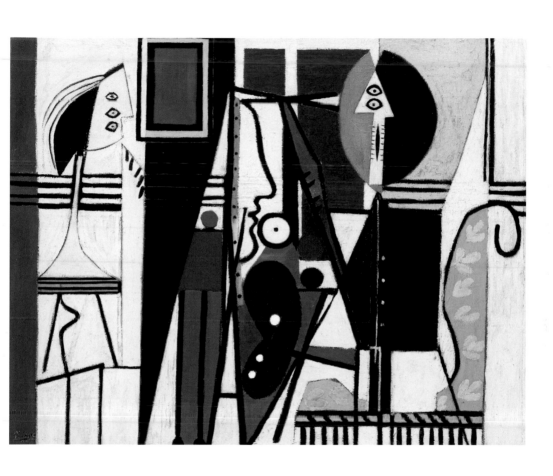

Painter and Model 1928
Oil on canvas, 51 ⅛ x 64 ¼" (129.8 x 163 cm)
The Museum of Modern Art, New York
The Sidney and Harriet Janis Collection, 1967

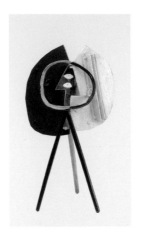 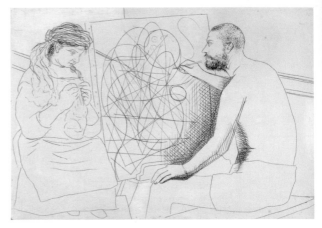

sculpture of the same year [fig. 11]. In both, a central triangle accommodates a doubled sign that Picasso most often used to indicate an eye, sometimes, however, extending its function to signify other orifices of the body. A sexual double entendre is signaled by the artist's mouth, a vertical vaginal slit surrounded by small hairs, its identity reinforced by the phallic extension of his arm and brush.

At left, in profile, the model is a sculpted bust mounted on a stand. Observing its nearly abstract appearance, the artist paints a classical profile on a canvas shown obliquely to the picture plane, at right. This switching of the abstract into the representational has its inverse parallel in a print Picasso made a year earlier [fig. 12] to illustrate Honoré de Balzac's short story "Le chef-d'oeuvre inconnu." There the artist and model are shown naturalistically while the image on the easel is abstract. If the subject of the print is the transformative power of the artist's hand and eye, its reach is extended in the later painting. Haunting Picasso's paintings of the late 1920s is a featureless silhouette indicating his presence. Here the profile stands as

32

11 *Head* 1928
Iron and brass, 7 ¹/₈ x 4 ⁵/₁₆ x 2 ¹⁵/₁₆"
(18 x 11 x 7.5 cm)
Musée Picasso, Paris

12 *Painter and Model Knitting*,
plate IV from *Le chef-d'oeuvre
inconnu* by Honoré de Balzac
1931 (etching executed 1927)
Plate: 7 ⁹/₁₆ x 10 ¹⁵/₁₆" (19.3 x 27.8 cm)
The Museum of Modern Art, New York
The Louis E. Stern Collection, 1964

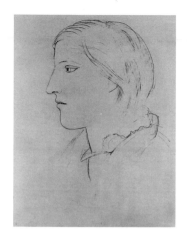
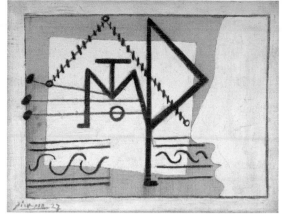

a doubled ideogram of himself and his new mistress, Marie-Thérèse Walter [fig. 13]. The previous year he had coded a rare acknowledgment of their still-clandestine affair into a small canvas [fig. 14]. There, punning on traditional Spanish associations of guitar playing and lovemaking, the rectilinear patterns of a guitar link the initials P and MT in a stick-figure monogram that barely touches the outlines of a profile that soon resurfaced in *Painter and Model*.

Complementing the surreptitious drama of *Painter and Model* is a vigorous formal control. Structured on a Cubist system of horizontals and verticals, the painting's composition is dominated by the repeating geometries of rectangles, triangles, circles, parallel lines, and dots. Depth, implied by the oblique placement of the artist's canvas and the sky behind the window, is not allowed to compromise the picture's overall flatness. Color is reserved for the inanimate objects; the picture's principal actors—artist and model—are both rendered in *grisaille*.

33

13 *Marie-Thérèse at Twenty* 1930
Lead pencil on paper, 24 ³/₄ x 18 ³/₄"
(62.7 x 47.5 cm)
Private collection

14 *Hanging Guitar with Profile* 1927
Oil on canvas, 10 ¾ x 13 ¾" (27.1 x 34.9 cm)
Alsdorf Collection, Chicago

Girl Before a Mirror (1932)

The most famous of the flood of images Picasso made of his young mistress, Marie-Thérèse Walter, in the early 1930s, *Girl Before a Mirror* is also the most complex. The artist's code for his beloved—classic profile, blond hair, and swelling lilac flesh—immediately identifies the young woman gazing into a mirror. But in Picasso's hands her commonplace act becomes ritual. Surrounded by a white halo, her profiled face is a serene, faintly rosy lavender that, in merging with a frontal view, forms a crescent—like the moon, yet intensely yellow like the sun, and also crudely brushed to suggest rouge, lipstick, and green mascara. Art historian Robert Rosenblum wrote that the double head is "a marvel of compression," containing within itself allusions to the two faces of Eve, the lunar cycle, the wedding of sun and moon, and, on a less universal level, Walter's night self and day self, her tranquility and vitality as well as her transition from innocence to initiation. Beyond its criss-crossing symbolic cues, the girl's head is another kind of compressed marvel. As William Rubin observed, "It is also a formal microcosm of the picture itself in its juxtapositions of warm and cool hues and its contrast of richly impastoed with thinly painted flat surfaces, all contained within a circular shape that is the leitmotif of the composition."

Overall, Picasso set the composition in a conceptual frame of shamanistic strategy. For him a mirror was magical; in his poetry he refers to the "mirror's black light" and its "open mouth ready to devour the sun." Here Walter stares into a mirror—called a *psyché* in French. If that were not enough, the

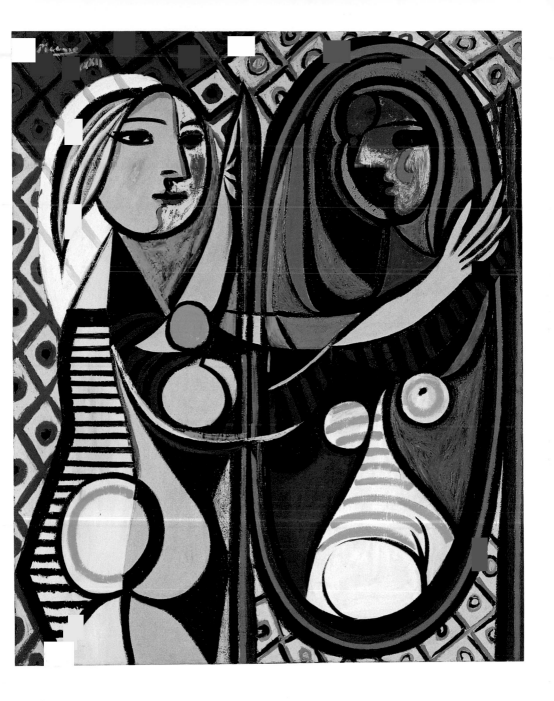

Girl Before a Mirror 1932
Oil on canvas, 64 x 51 ¹/₄" (162.3 x 130.2 cm)
The Museum of Modern Art, New York
Gift of Mrs. Simon Guggenheim, 1938

picture itself is based on a traditional Vanity, the image of a woman gazing into a mirror that reflects her as a death's head. In Picasso's variant the girl's curving violet belly, upper thigh, and rounded breasts, together with a circular green womb on a direct, vertical axis with her head, proclaim her intense awareness of her own sexuality. Reflected to the right, her robust physicality seems deflated, her lavender flesh white and no longer integrally connected to her head. Above her skewed breasts and phallically inclined arm, the contours of her profile are not so much altered as darkened—her eye is black and ghostly and her forehead is suffused with red and occluded by a dark-green oval. Where contrasts of brilliant reds, yellows, and greens, offset by black, animate the picture as a whole, their play is muted in the mirror's oval. There Picasso's deployment of a somber blue shrouds the girl's reflection and symbolically suggests the mysteries of another self. The alternating colors of the diamond-patterned wallpaper evoke the costume of Harlequin, the *commedia dell'arte* character with whom Picasso often identified. With an eye centered in each lozenge, he is an implicit witness to the silent dramatics of Walter's psychic and physical transformations.

Bather with Beach Ball

(1932) Wonderfully, perversely comic, this elephantine goddess improbably levitating across a beach is yet another celebration of Picasso's all-consuming involvement with his young mistress, Marie-Thérèse Walter. For the year 1932 she is unusually sporty. In the majority of Picasso's images of her from this period, she is in an interior — passive and voluptuous, lost in reverie or the abandon of sleep. Yet, earlier allusions to her, in Picasso's 1928 series of bathers in Dinard, Brittany [fig. 15], or the swollen androgynous creatures made as studies for a monument to Apollinaire [fig. 16], display her athleticism and her love of beachside games. Though largely inspired by Walter, these figures, with their grotesque, even somewhat repellent contours, embody both Picasso's tenderness for his mistress and the violent intensity of his feelings toward Olga Picasso, his rejected wife. Such conflations of identity are to be found in almost every phase of Picasso's art. His biographer John Richardson has written, "Picasso would not be Picasso if . . . he did not scramble his

15 *Surrealist figures* (notebook 1044) 1928
Chinese ink and pencil on paper, 15 x 12 $^3/_{16}$"
(38 x 31 cm)
Marina Picasso Collection

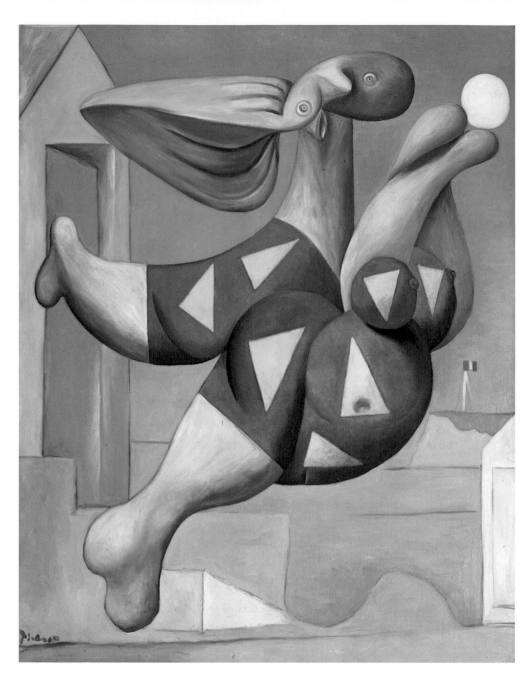

Bather with Beach Ball 1932
Oil on canvas, 57 ⁷/₈ x 45 ¹/₈" (146.2 x 114.6 cm)
The Museum of Modern Art, New York
Partial gift of an anonymous donor and promised
gift of Jo Carole and Ronald S. Lauder, 1980

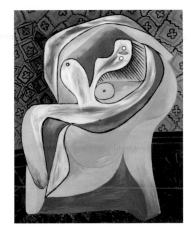

carefully differentiated images and perversely see the beloved mistress and hated wife in terms of each other."

By 1932 Picasso had largely managed to exorcise the evil spirit of Olga, and with few exceptions, such as the sexually aggressive ogress of *Repose* [fig. 17], Walter was the uncontended mistress of his heart and hand. Yet however distanced this odd bather is from the threatening figure in *Repose* or the praying-mantis beach beauty of *Seated Bather* of 1930 [fig. 8], her immediate appeal as a "squishy sexual toy" (as William Rubin described her) is shadowed by dark humor, if not directly by the ghost of the despised wife.

Picasso's belief that the "boundary between delirium and imagination is never clear," led him, Robert Rosenblum observed, "to invent astonishing puns" to describe this Surrealist beach scene. The bather's costume covers breasts, belly, and buttocks of such round precision and gaily colored aspect that they suggest the beach balls ornamented with triangular patterns seen in the Dinard series. Uncovered, her gray, tumescent limbs seem composed of the same inflated rubber as the object she pursues.

39

16 *Bather (Metamorphosis II)* 1928
Plaster, 9 $^{1}/_{16}$ x 7 $^{1}/_{16}$ x 4 $^{5}/_{16}$"
(23 x 18 x 11 cm)
Musée Picasso, Paris

17 *Repose* 1932
Oil on canvas, 63 $^{3}/_{4}$ x 51 $^{1}/_{4}$"
(162 x 130 cm)
Private collection

In fact, Walter's beach ball prey is unlike any of those that make up her astonishingly rounded torso. Unmodeled and flat against the sky, it looks like the moon—eluding her clumsy, fingerless hands. In its staging of the interplay between the two and three dimensional, this *plein air* scene formally and metaphorically captures Walter's encompassing presence in Picasso's life at the time. Fully occupying the foreground, her immense figure is compressed into a flattened seascape; its deepest reach, signaled by a tiny French flag, seems, like the far-off moon or proximate beach ball, situated along with the ballooning bather herself on the plane of the picture.

She-Goat (1950) This engagingly rude animal belongs to a group of assemblage sculptures Picasso began making in 1950 at his studio in Vallauris, France. It may be that the deadpan playfulness of this goat and such contemporaneous pieces as *Baboon and Young* [fig. 18] is a result of Picasso's delight in the two young children, Claude and Paloma, he had recently fathered with his companion, Françoise Gilot.

According to Gilot, Picasso formed the idea of making a sculpture of a goat and then set out scouring local dumps to find suitable materials to be assembled and set in plaster. A participant in one of these foraging expeditions recounted how excited Picasso became when he spied an old wicker basket in a field; shortly thereafter it served as the goat's rib cage and pregnant

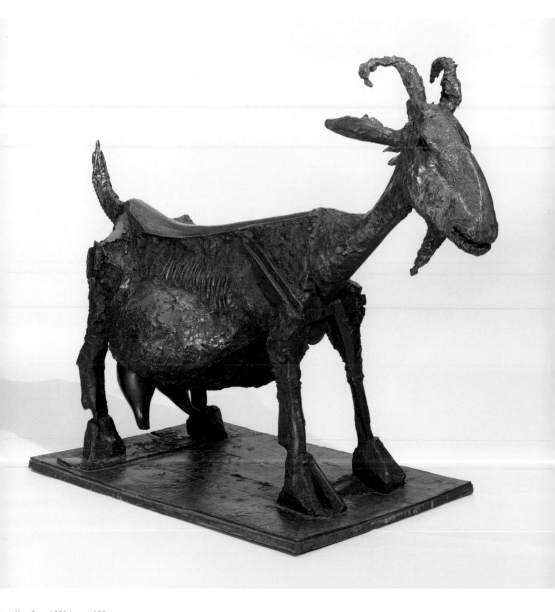

She-Goat 1950 (cast 1952)
Bronze, after an assemblage of palm leaf,
ceramic flowerpots, wicker basket,
metal elements, and plaster,
46 ³/₈ x 56 ³/₈ x 28 ¹/₈" (117.7 x 143.1 x 71.4 cm)
The Museum of Modern Art, New York
Mrs. Simon Guggenheim Fund, 1959

belly. For the animal's backbone and forehead Picasso used a palm branch he had scavenged some two years earlier. The legs were tree branches, the sternum a tin can, the haunches metal strapping, the horns and beard a section of vine, the ears cardboard, and the tail and whiskers copper wire. As appropriate for an animal of such randy repute, Picasso took particular care with this she-goat's udders and genitalia. For the former he broke and reshaped milk jars to form swollen teats. For the prominent vulva he used the partially bent top of a can. Between it and the tail he made an anus from a protruding pipe.

As symbols of Arcadian fertility and joy, goats often gambol about with nymphs and fauns in Picasso's pictures of the Antibes period, around 1946. This sculpture—the artist's construction, cast in bronze—was sometimes used as a tethering post for Picasso's pet goat, which otherwise had the run of the house and garden at his villa La Californie [fig. 19]. Even in bronze, *She-Goat*'s origin in bricolage is evident and it adds to her earthy appeal.

42

18 *Baboon and Young* 1951 (cast 1955) Bronze, 21 x 13 ¹/₄ x 20 ³/₄" (53.3 x 33.3 x 52.7 cm) The Museum of Modern Art, New York Mrs. Simon Guggenheim Fund, 195

19 Picasso's pet goat tethered to *She-Goat*, Villa La Californie, Cannes, France, 1957. Photography Collection, Harry Ransom Humanities Research Center, The University of Texas at Austin

Page 43 Picasso with *She-Goat*, Vallauris, France, 1950. Musée Picasso, Paris

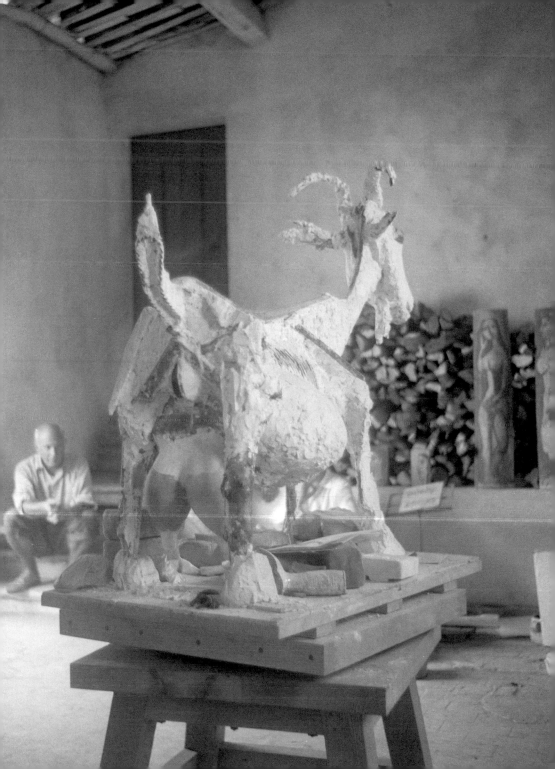

Picasso in his studio at Rue Schoelcher, Paris,
1915–16. Photographic Archive, The Museum
of Modern Art Archives, New York

Pablo Picasso was born in 1881, in Málaga,

Spain. He began to study art at age seven under the instruction of his father, an art teacher, and progressed so quickly that in 1891, at age ten, he began completing details of his father's paintings. In 1899 Picasso abandoned formal training and moved to Barcelona and then to Paris, where he settled permanently in 1904. His groundbreaking 1907 painting *Les Demoiselles d'Avignon* marked the beginning of a period of radical innovation. During the next six years, Picasso, together with Georges Braque, pioneered the style now known as Cubism, which was to revolutionize twentieth-century art.

Aside from his seminal involvement with Cubism, Picasso never belonged to any recognized art movement. For the rest of his long life he freely combined ideas extrapolated from Cubism with forays into Neoclassicism, experiments with Surrealism, and whatever else the panoply of art and life suggested to him. No subject was alien to him, and the vast array of paintings, sculptures, drawings, and prints he produced range through and sometimes combine political protest, high comedy, tragedy, and a highly charged eroticism. After World War II Picasso's fame grew to proportions unique to the experience of any living artist, past or present, and his work effectively became an eclectic one-man movement, indispensable and pervasive in his own time and after. Among countless others, his art decisively touched the careers of such divergent artists as Henry Moore, David Smith, Piet Mondrian, Jackson Pollock, Willem de Kooning, and Jasper Johns. He died in Mougins, France, in 1973.

Produced by
The Department of Publications,
The Museum of Modern Art, New York

Edited by Rebecca Roberts
Designed by Amanda Washburn
Production by Elisa Frohlich

Printed and bound by Oceanic
Graphic Printing, Inc., China
Typeset in Avenir
Printed on 140 gsm Gold East Matte
Artpaper

Library of Congress Catalogue Card
Number: 2008921259
ISBN: 978-087070-723-0

Published by
The Museum of Modern Art
11 West 53 Street
New York, New York 10019-5497
www.moma.org

Distributed in the United States and
Canada by D.A.P./Distributed Art
Publishers, Inc., New York

Distributed outside the United States
and Canada by Thames & Hudson,
Ltd., London

Printed in China

Photograph Credits